Within this book you will find a collection of dreamy doodle drawing prompts. Let the words inspire you. Relax, free your mind and let your soul dance on the pages of this book through your doodles.

Waves

Sunshine

Glow

Enchanted

Mushrooms

Circles

Adventure

Warm

Roots

Thankful

Feather

Shell

Stars

Butterfly

Light

Embrace

Rainbow

Tiny

Moonlight

Wind

Home

Celebration

Wings

Draw your Name

Joy

Sunset

Tree

Swirls

Magic

Shadows

Pattern

Flourish

Dreamcatcher

Map

Wanderlust

Mountain

Bare Feet

Shapes

Wild & Free

Sleep

Palm Tree

Paint

Berries

Celestial

Tea

Hot Air Balloon

Torn

Hair

Eclipse

Secret

Plant

New

Music

Goosebumps

Heart

Fire

Fairytale

Brave

Space

Arrow

Lucky

Dance

Soothing

Gap

Crystal

Spoon

Bridge

Dusk

Gnome

Wish

Twinkle

Wand

Night

Day

Seed

Laughter

Explore

Down

Mermaid

Bloom

Bubbles

Curious

Begin

Winter

Doodle With Your Favorite Words

Mandala

Cactus

Treasure

Path

Fairy

Fireflies

Wisdom

Eyes

Shine

Fly

Kingdom

Grass

Time

Dwelling

Crystal Ball

Beauty

Dew Drops

Gate

Hands

Complete

Growth

Endless

www.ingramcontent.com/pod-product-compliance
Lightning Source LLC
Chambersburg PA
CBHW081603220526
45468CB00010B/2747